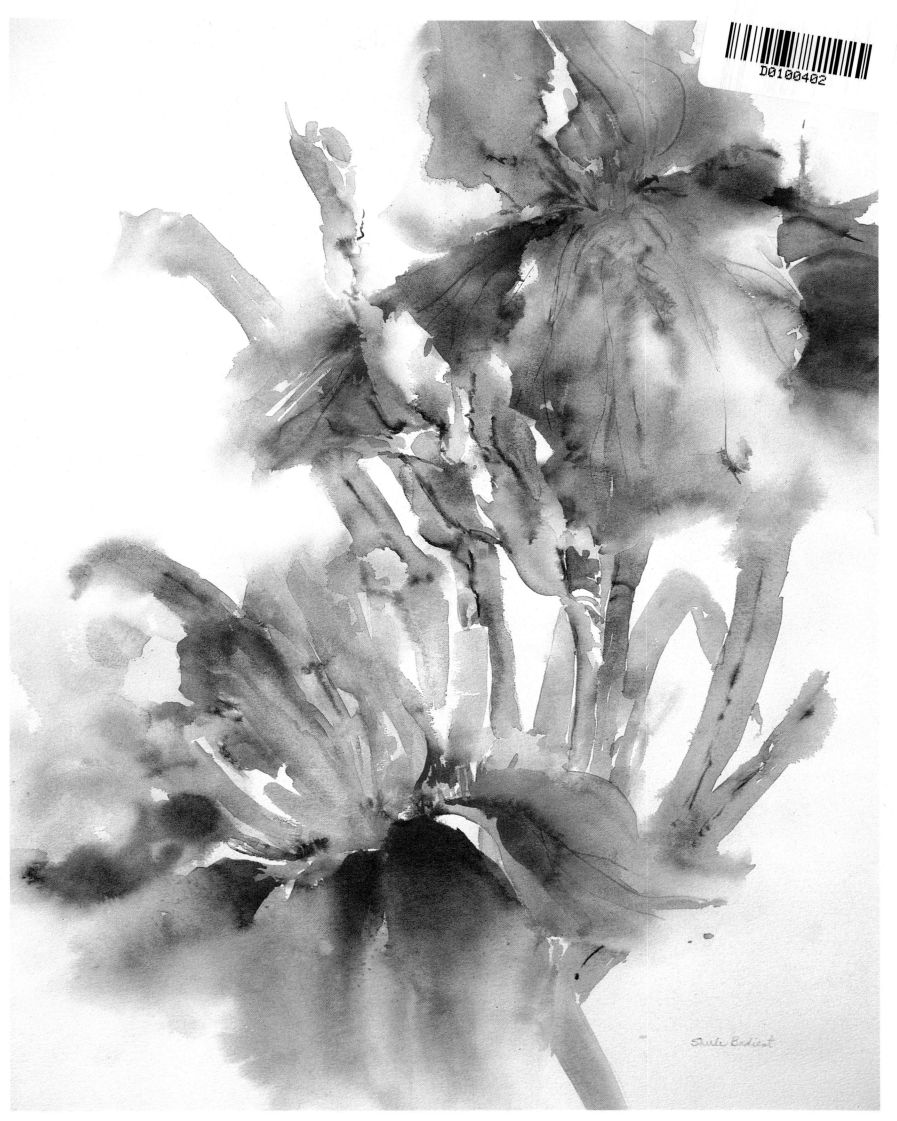

Iris

1

Supplies

You may be tempted to buy cheap materials when you are just beginning, but your results will be far less satisfactory if you do. Give yourself every opportunity to succeed by buying the highest quality supplies you can afford.

PAPER

I recommend 140 lb., acid-free, 100% rag paper (there are both linen rag and softer cotton rag papers available). A full-sheet (22" x 30") can easily be cut into smaller pieces, which is cheaper than buying a pad or a block. Papers come in three textures: hot-press (smooth), cold-press (slightly textured), and rough.

PAINT

Buy only artist's grade paints. Student grade paints contain a chalk-like filler that reduces their transparency—the quality that draws most people to watercolor.

BRUSHES

Ask your art supply dealer if you can water-test a few brushes. Don't waste your money on a brush that flops over when wet. Start with five good synthetic brushes in the following sizes: a 1" wash brush (the word "wash" is the key; the bristles are fuller at the metal ferrule and longer than a 1" flat brush), a 1/2" flat brush with beveled handle, a #8 and a #12 or 14 pointed round brush, and a #3 or 4 script liner for fine detail. Note: When you do a full-sheet painting a 1-1/2" wash brush will be essential.

MISCELLANEOUS

- #4B pencil (for sketching)
- White plastic eraser
- 2" natural sponge (for wiping out)
- Waterproof, fine-tip black marker, or charcoal, or black pastel
- Terry cloth rag or cheap sponge (for wiping excess water from brush)
- Pump spray bottle
- Fine-mist spray bottle (hairspray bottles work great)
- Pop-up facial tissue
- Plastic palette (with cover)
- Water container
- 1/4" mahogany or plywood support board (many lumber yards will cut plywood to size for you; have them cut it 1" larger than the paper)
- Two or more bulldog clips (for clipping paper to the support board); to prevent rust, cover the flanges with clear tape
- Wax crayon or liquid masking fluid

Mixing Colors

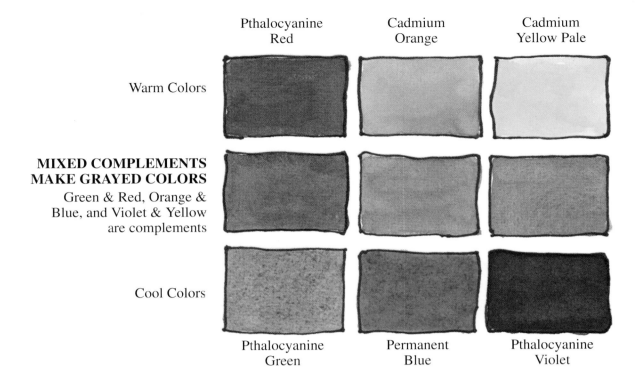

	Pthalocyanine Red	Cadmium Orange	Cadmium Yellow Pale
Warm Colors			

MIXED COMPLEMENTS MAKE GRAYED COLORS
Green & Red, Orange & Blue, and Violet & Yellow are complements

Cool Colors

Pthalocyanine Green · Permanent Blue · Pthalocyanine Violet

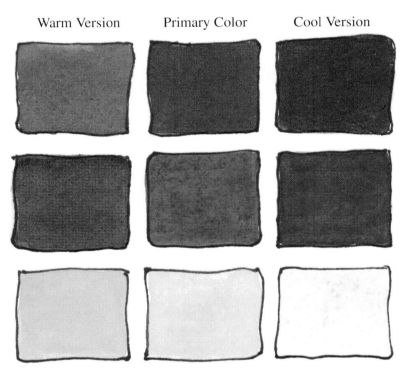

Warm Version · Primary Color · Cool Version

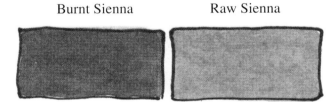

Burnt Sienna · Raw Sienna

Your palette should include the designated primary colors of red, yellow, and blue, along with a warmer version of each primary (toward orange or yellow) and a cooler version (toward purple or blue).

Knowing the "temperature" of your colors is very important for color mixing. Bright colors are mixed by selecting two colors that contain properties of the desired color. For example, if you wish to mix a bright violet, select a red that has some blue in it, such as alizarin crimson, and a blue that has some red in it, such as permanent blue. Conversely, cadmium scarlet mixed with permanent blue results in a more grayed violet because cadmium scarlet is a warmer red, containing yellow, which is the complement of violet.

Burnt sienna and raw sienna are beautiful colors when used individually. When used for mixing, they gray colors which makes them ideal for making natural-looking greens. Mix these colors with only one other color for the best results.

SUGGESTED COLORS:
- Permanent Blue
- Cobalt Blue*
- Antwerp Blue
- Cerulean Blue
- Pthalocyanine Green
- Burnt Sienna
- Raw Sienna
- Aureolin Yellow
- Cadmium Yellow Pale*
- Indian Yellow
- Cadmium Orange
- Cadmium Scarlet
- Pthalocyanine Red (brands vary)*
- Rose Madder Genuine
- Permanent Rose
- Alizarin Crimson
- Cobalt Violet
- Pthalocyanine Violet

Denotes designated primaries

This list of colors includes a warm and a cool version of my chosen primary colors. Some of the colors are only available in specific brands. Permanent blue is a more transparent substitute for French ultramarine blue.

Composition from Photos

These photos of a grand magnolia were taken with a zoom lens. This tree-like shrub grows 25-30" tall, but even when your subject is more accessible, plan to take many close up photos from different angles.

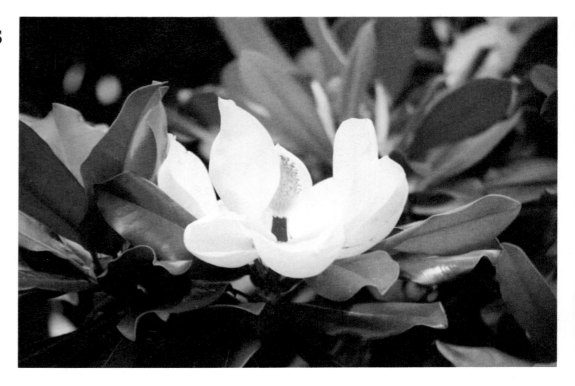

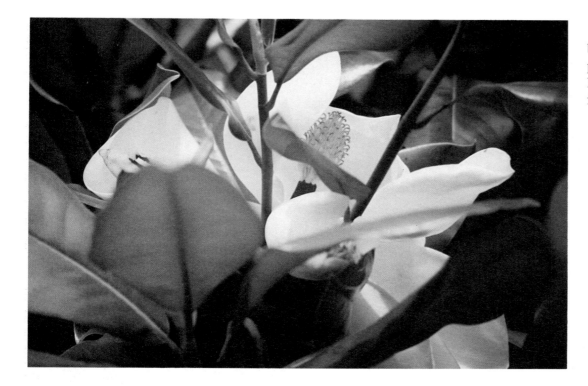

This "ant's-eye view" records details of the blossoms, the plant structure, and the foliage. The prismatic reflection of light through the camera lens can provide color ideas that are not only useful, but inspiring.

Aim your camera slightly upward to take maximum advantage of the light filtering through the subject. Setting the camera at f-stop #2, or even smaller for a short depth of field, creates a soft, out-of-focus background.

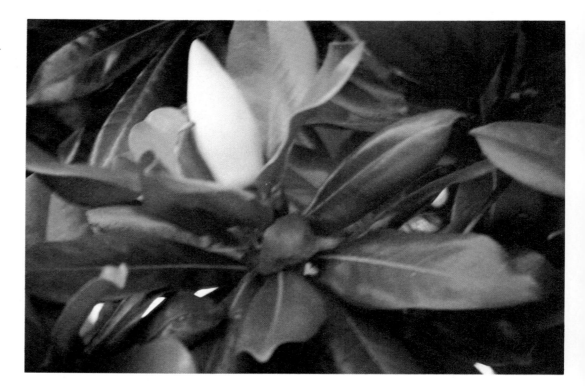

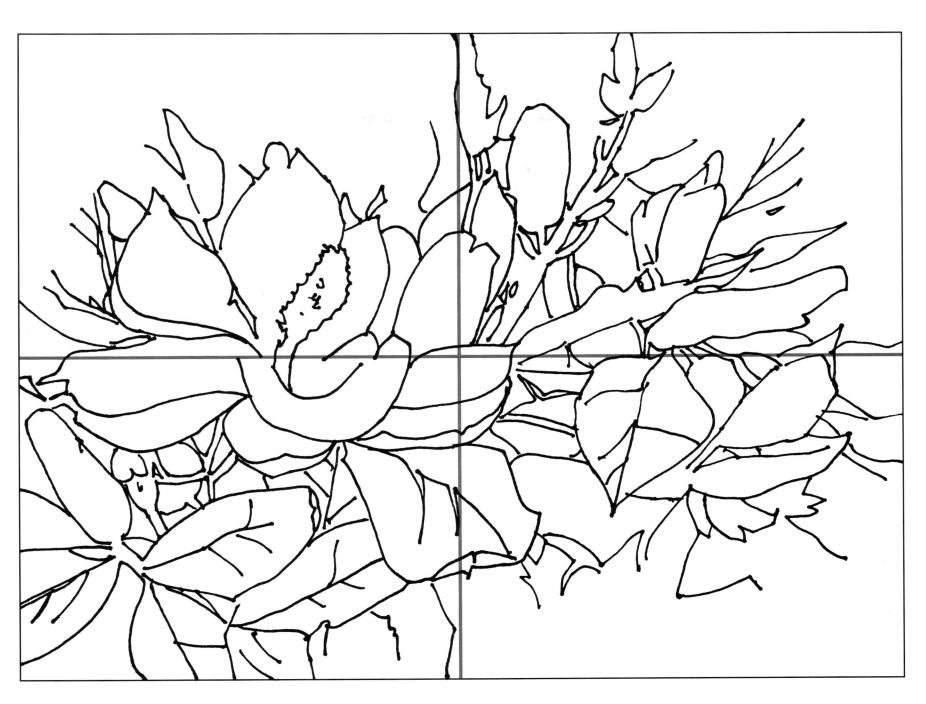

Designing a Painting

Draw blossoms, buds, and leaves in groups and varying sizes on separate sheets of paper, and cut them out. Lay the pieces on a fresh sheet of 8" x 11" paper and move them around until you are pleased with the arrangement. Tape the pieces down, then draw a rectangle around them to isolate the design you want. Delete anything that falls outside of the rectangle. This is a good design-training tool and it will save you from having to do many individual sketches. The 8" x 11" paper is approximately the same proportions as a full-, half- or quarter-sheet of watercolor paper. This type of sketch will solve composition problems and eliminate the need for a lot of erasing on the delicate watercolor paper.

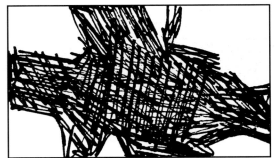

Next, draw a horizontal line and a vertical line through the center of your sketch to divide it into quarters. The point of interest in your painting should normally be off-center and away from the edges. If the point of interest is in the exact center, you may want to rearrange the elements of the composition. The point of interest should have both the darkest and brightest colors, the largest white shapes, and the hardest edges. The color should become more diluted, grayed, and soft-edged as it moves toward the edge of the paper.

Now use a 4B pencil (very lightly) to divide your watercolor paper into quarters. The lines create reference points for redrawing your sketch on the watercolor paper; they can be erased later. Once you have redrawn the sketch on your paper, you can make a dark pattern design on a separate piece of paper, such as the one to the right. This pattern is a plan for the application of paint; it is used to connect color to all four edges of the paper and create a backdrop that will help the eye focus on the main subject. It will also allow you to place the necessary contrast where needed to define the subject. Refer to the dark pattern design for the initial washes and the placement of darks later in the painting process. There will be a variation of color and value within the design area as the paint is applied. (Note: "Value" is the degree of lightness or darkness of a color.)

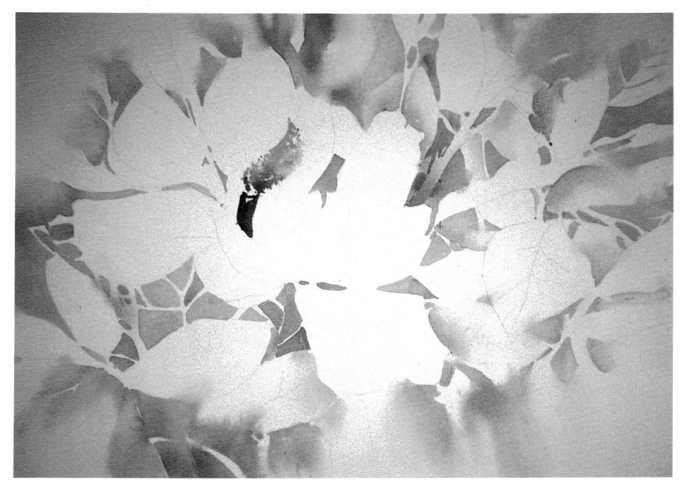

BLOCKING IN COLOR

Use your 1" wash brush to block in the background with light and mid values of antwerp blue, cadmium scarlet, raw sienna, and cerulean blue. Work your way around the the entire picture, but paint *around* some shapes to keep them white. These white shapes can be painted or shaded once the washes are dry, if desired.

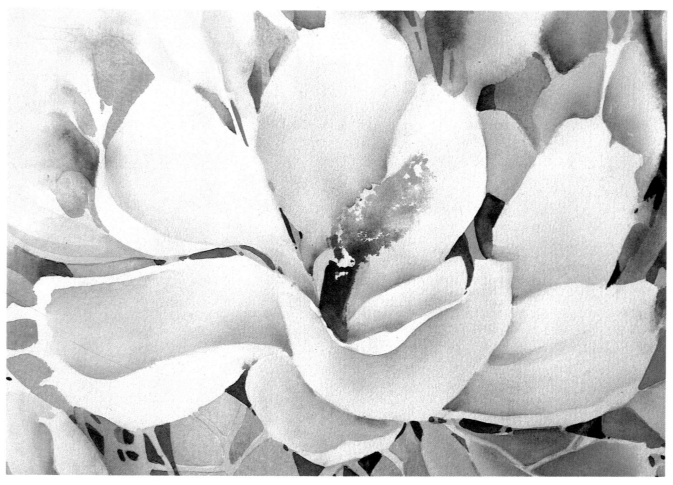

SHADING THE WHITE BLOSSOM

After the initial washes have dried, shade the blossoms with mixtures of antwerp blue, cadmium scarlet, and raw sienna. Vary the colors in the mixtures to vary the tones. The light blossoms become the reference point for the values of the entire painting; avoid creating a background that competes with them.

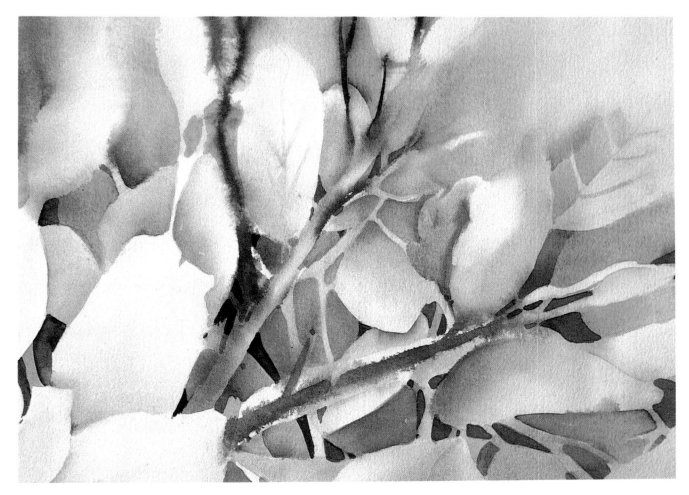

DIVIDING SPACES

Now use your #8 and #14 pointed round brushes to apply darker mixtures of antwerp blue, cadmium scarlet, raw sienna, and burnt sienna. Divide the negative spaces and push specific areas of the painting into the background. The dark pattern design is used once again to guide the placement of the darks.

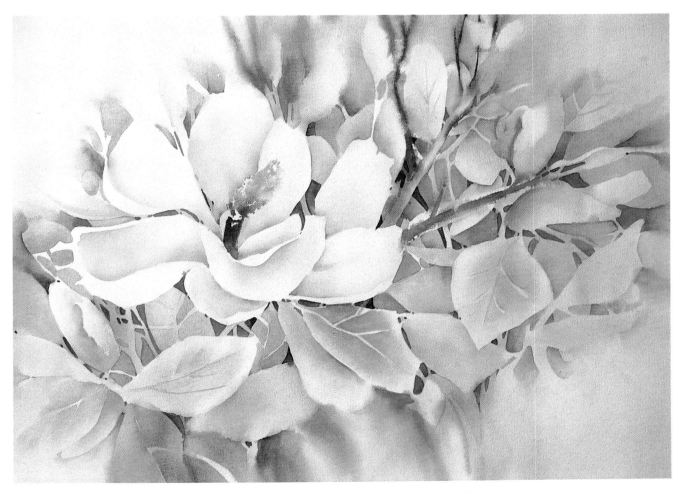

GLAZING

Glazing is the application of a thin wash of transparent color. Glazes of the same colors used previously are applied to subdue some of the smaller white shapes so that the large blossom is the most prominent shape. This type of painting is called "high key" because it does not have any intense darks in it.

HARD EDGES

A very distinct linear edge (called a "found" edge) forms when the brush strokes meet dry paint or paper.

SOFT EDGES

A soft or blurred edge (called a "lost" edge) forms between two wet colors or when the brush strokes meet wet paper.

PASSAGEWAYS

Passageways are areas that allow the eye to travel through the painting. These are formed by areas of white that connect one shape to another or where soft-edged colors of different shapes meet.

Fall Leaves

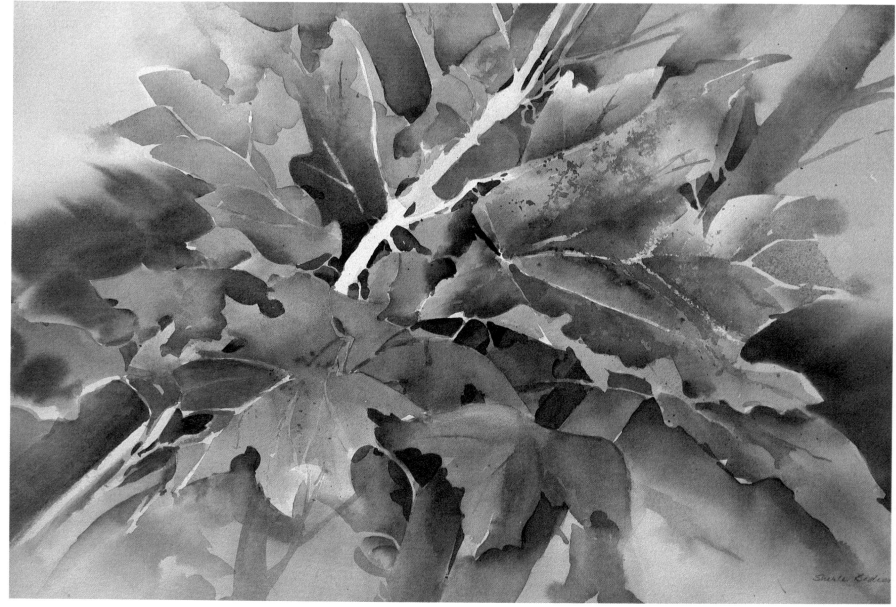

One of the most effective ways to direct the viewer's eye through a painting is to make different types of edges. Hard edges capture the eye and create emphasis; soft edges and passageways create a path for the eye to travel through the painting—from the background to the foreground and between shapes.

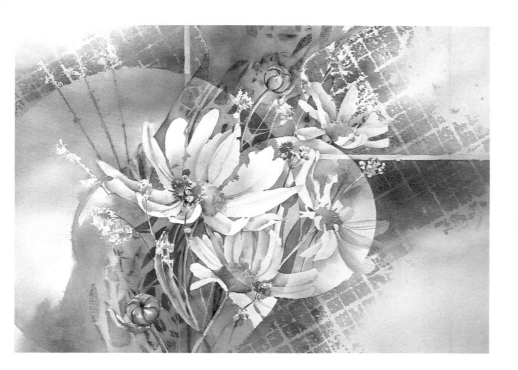

Four Uses for Line

- Detail
- Direction
- Contrast
- Decoration

Line is a valuable tool for the artist. Line can be painted or drawn in with charcoal, pastel, or a permanent, waterproof marker. White line can be created by using a clear wax crayon or masking fluid in desired areas; they will repel the paint, preserving the white of the paper.

Charcoal was used for the initial drawing of *Wild Morning Glories*. The charcoal is a decorative contrast to the delicate painting.

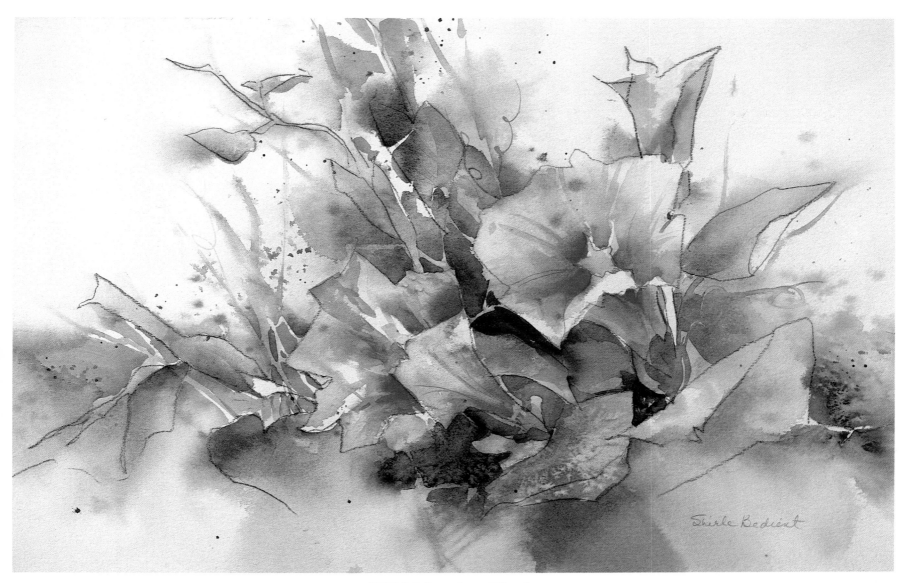

Wild Morning Glories

The star-like patterns of light in this example were made with salt. To create this effect, sprinkle salt onto the paint just as it begins to lose its wet shine. Let the paint dry completely, then carefully brush off the salt with your fingertips. Be sure to remove all of the salt before applying more paint or you will contaminate the paint on your palette. Try different types of salt: kosher, pretzel, or regular table salt. Each will produce a different pattern. Note: This technique works best for initial washes on fresh white paper.

Creating Texture with Cheesecloth

This technique is a spontaneous way to begin a painting. You do not draw the subject first, so there is an element of the unknown. You may have to experiment several times before you come up with a good beginning design. Very rough or very smooth texture papers work best for this. The illustration below was done on bristol paper.

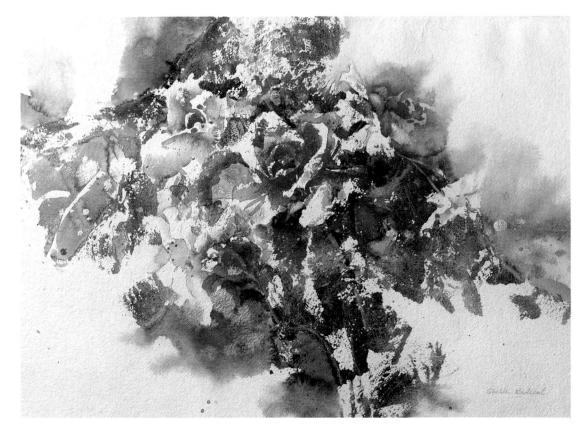

Take a piece of cheesecloth larger than your paper and poke several holes in it with your fingers. Make some of the holes large, elongate some, and stretch the threads in some areas. Then use your fine-mist spray bottle to lightly mist the cloth with water and place it on your watercolor paper. Arrange the cloth so the largest holes and the threads make an interesting pattern and create a focal point slightly off-center. Don't worry about wrinkles because they add to the design.

Hold the cheesecloth down with the thumb and index finger of your free hand. Then, following your dark pattern design, apply the paint while misting the edges of the cloth with your spray bottle. Be sure to to leave areas of white within the design .

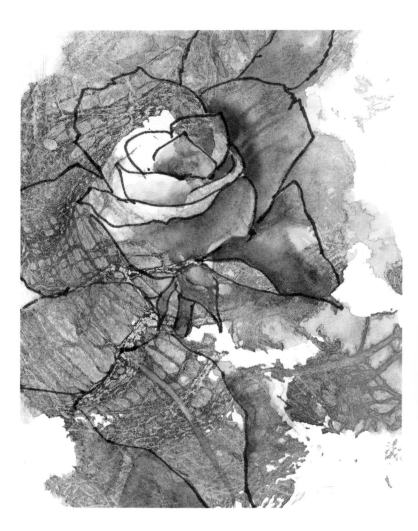

Once the cloth and the paper are completely dry, remove the cloth and study the abstract design you have created. Look at the white spaces and colored shapes, and imagine what floral image might fit with them. Rotate the paper and look at it from different angles. Once you have decided on a design, use a pencil to draw the subject over the abstract image. Make use of some of the color shapes and some of the white spaces to align your drawing. (Note: I used a black marker for demonstration purposes only.)

Finally, bring out the desired shapes with glazes of color. Create hard edges around the pencil drawing, and soften the outer edges with strokes of clear water. Save as much of the cheesecloth texture as possible.

Using Lace Paper to Paint a Background

Oriental lace papers are fiber papers that have small openings, like lace. They come in many geometric patterns and are used mainly for collage and decorative purposes. For watercolor painting, they are used to create texture. The solid portions of the lace paper block the paint from the watercolor paper, leaving behind a white geometric design when the lace is removed.

Before painting, use your 4B pencil to draw the flowers and a leaf or two on your watercolor paper. Make sure you can see the pencil lines through the holes in the lace paper.

Next, lay the drawing on your board, and place a larger piece of lace paper over it. Use bulldog clips to secure the edges of both papers to the board. Do not remove the lace paper or the clips until the washes are completely dry.

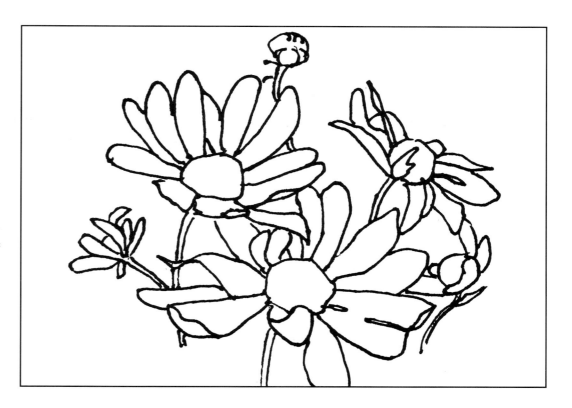

The dark pattern design is your guide for applying the washes over the lace paper and around the drawing.

GETTING READY TO PAINT

Premix large puddles of the colors you plan to use in the center of your palette. (I used cobalt violet, cobalt blue, and raw sienna for the background, and raw sienna, indian yellow, and some cadmium scarlet for the centers of the flowers.) Premixing the paint allows you to work quickly so the colors will overlap and blend softly.

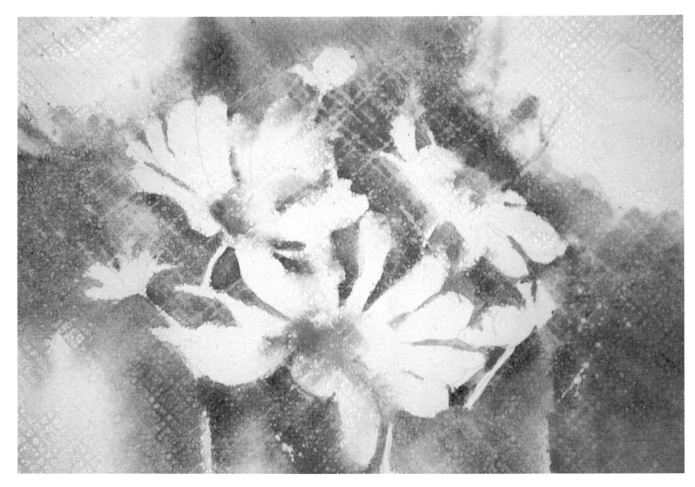

APPLYING THE COLOR

Wash in the background colors over the lace paper, allowing the colors to overlap and blend together. Mist the outer edges of the brush strokes with water so they will blend softly. The paint will seep through the texture in the paper and create a pattern on the watercolor paper. Apply the color intensely because some of it will be lifted off with the lace paper. Be sure to preserve the white areas!

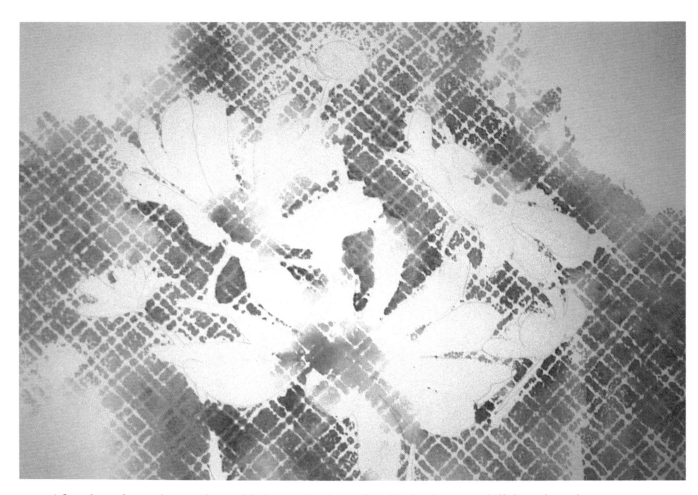

After the paint and paper have dried completely, remove the lace paper. The resulting design should have some edges that show the shapes of your drawing. Notice how much lighter the colors appears once the lace paper is removed.

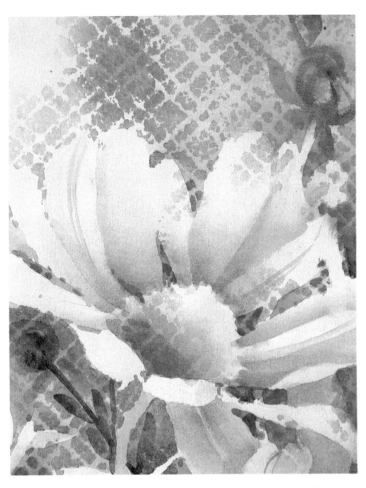

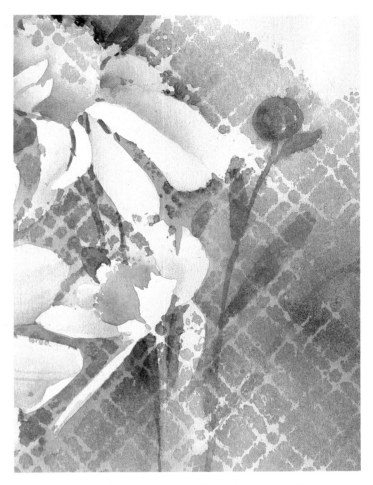

Next, add transparent glazes of cobalt blue. Create some hard edges to define specific areas.

Now use clean water to soften the edges of some of the brush strokes into the background. A hair dryer (held 6-8" away from the paper) will help speed the drying time. Paint the leaves, buds, and stems with a green mixture of antwerp blue and raw sienna.

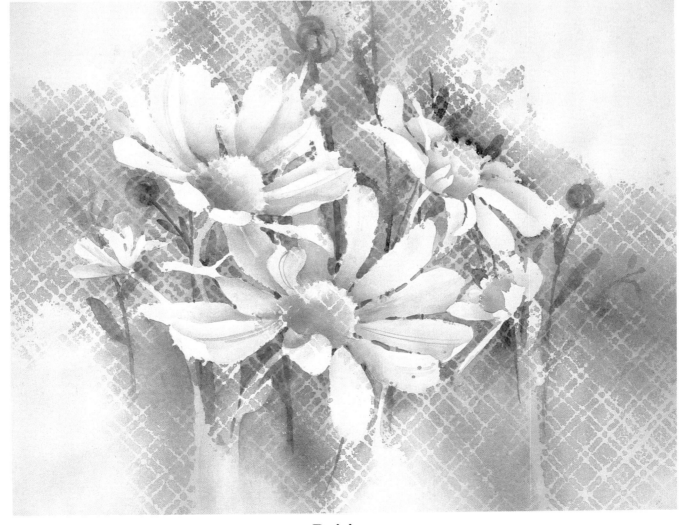

Daisies

SIMPLICITY AND CHARM

A transparent glaze of cobalt blue is washed over some of the background texture to add strength to the dark pattern design and create depth.

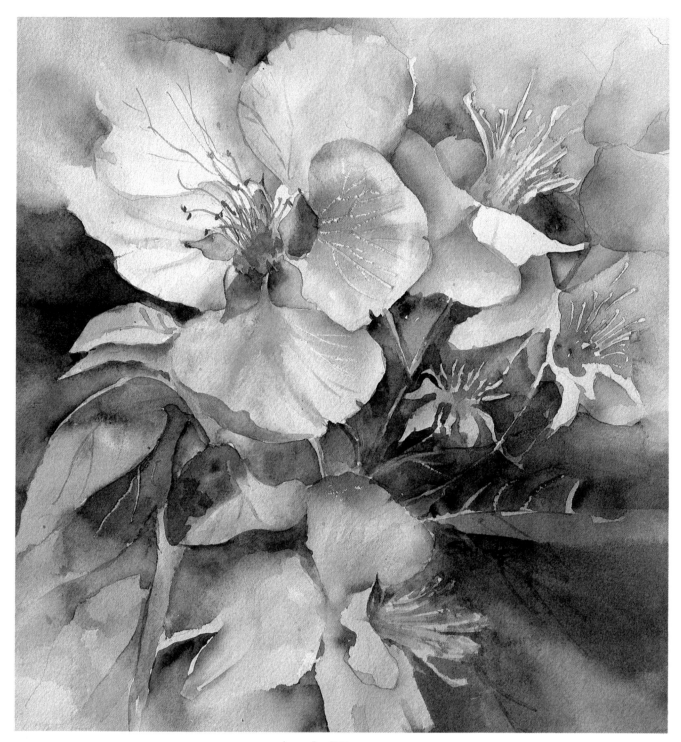

Apple Blossom

Scratching in Details

Light detail lines, such as the flower and leaf veins, can be scratched out of the paint with the bevel end of your 1/2" flat brush. This should be done just as the paint begins to lose its wet shine. To create the dark lines, scratch in the veins while the pigment is wet.

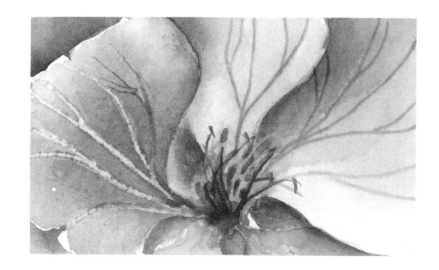

Simplifying Detail

The small blue flowers in *Bridesmaid's Bouquet* act as a bridge between the larger, fluid shapes of ivy leaves and peony blossoms. These blue flowers aren't painted realistically, but they emerge because small background shapes were added to outline them. This type of painting around an object or a part of it is called "negative painting."

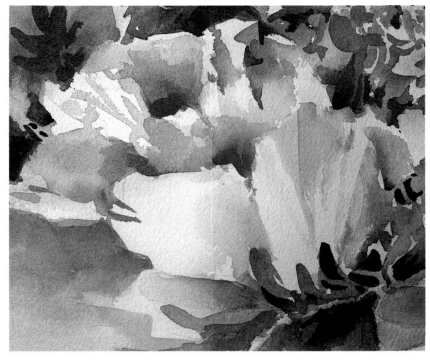

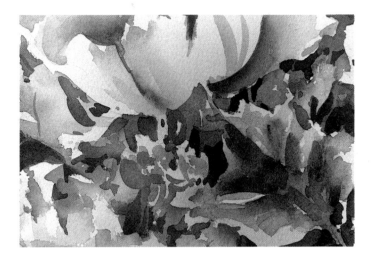

The elements of any painting are defined by the contrast of light against dark, as shown in this detail of the peony blossoms. For the greatest contrast, use a deep color next to the white of the paper.

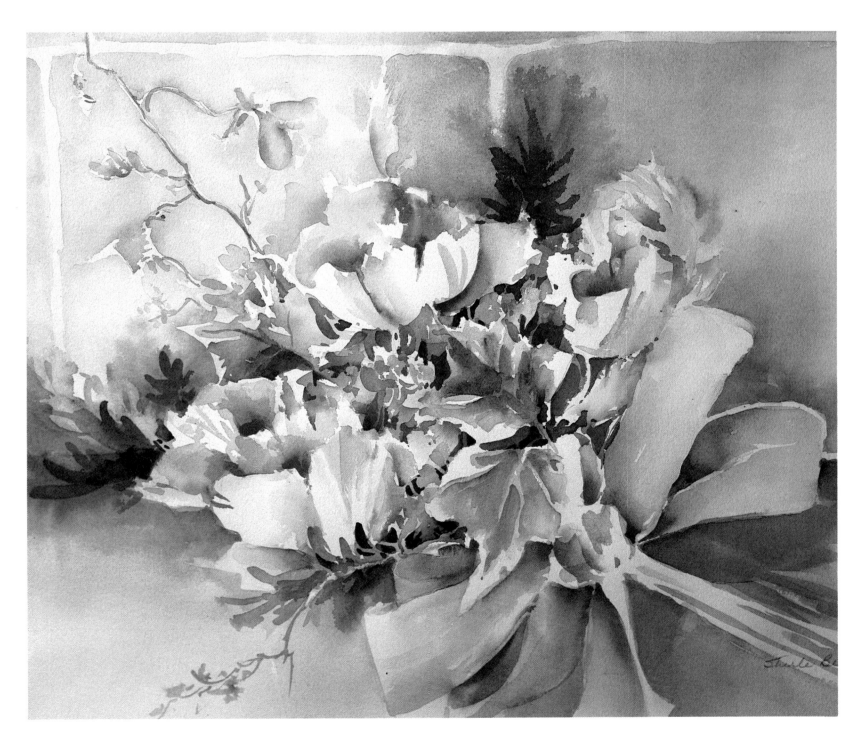

A dark pattern design gives you a guide for applying the paint.

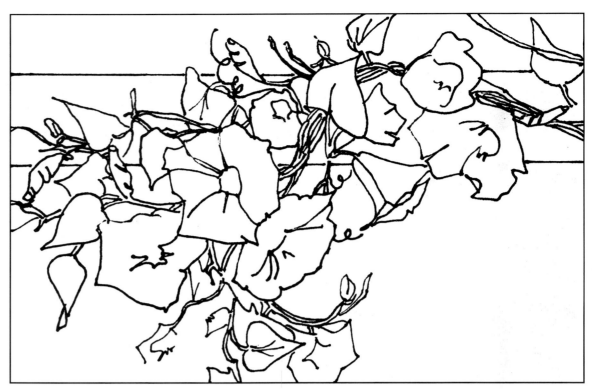

A well-drawn sketch is like a map—it will keep you from getting lost while you're painting.

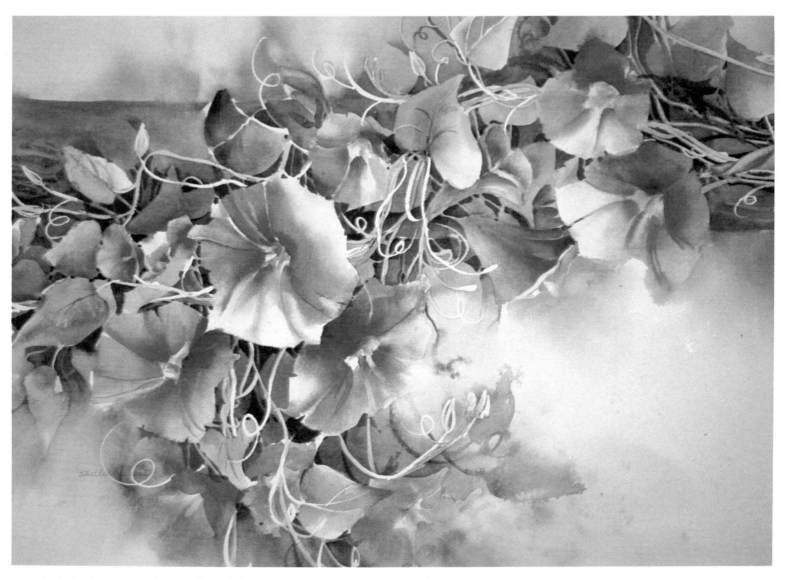

This is the companion to the original piece shown on the opposite page. This one was painted six months after the first. It was designed to hang to the left of the first piece, as shown.

Two different paintings of the same size can be framed alike and hung side by side. They are visually tied together by the continuation of one image to the other.

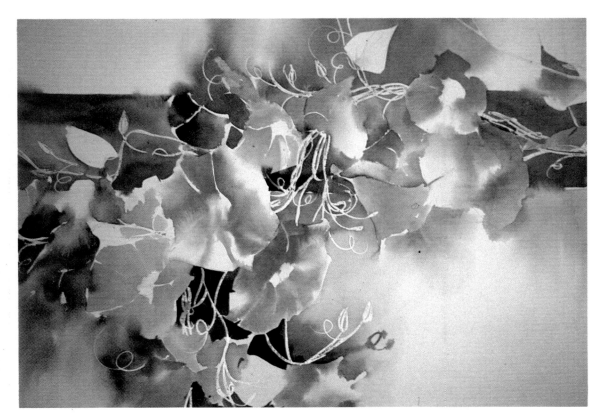

Morning Glories

When applying the initial washes, soften some edges with your fine-mist sprayer and keep others hard. Work around the drawing: saving whites, combining hard and soft edges, and varying the color. Small, dark shapes are carefully placed to define shapes and create the illusion of depth.

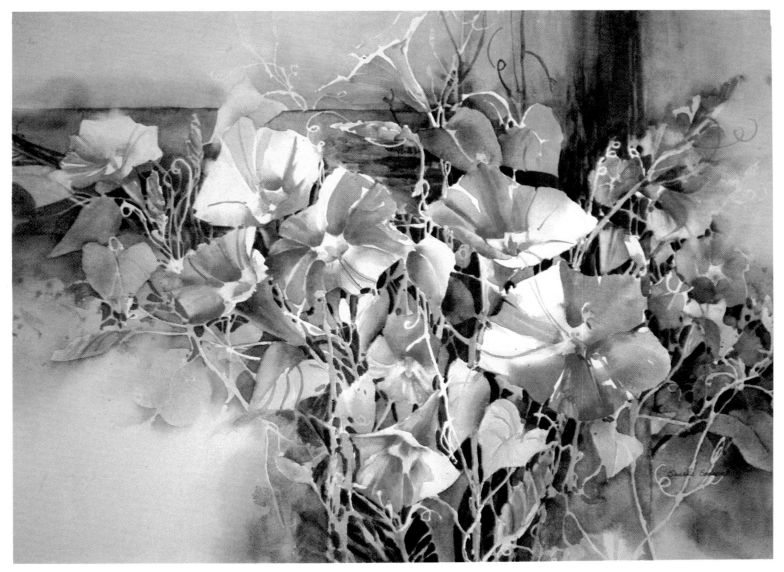

Liquid masking fluid was used to protect the white lines in this painting. Masking fluid is applied to the desired areas with a small brush or stick, allowed to dry completely, and then painted over. The mask protects the paper from the paint, leaving it clean and white. When the paint is dry, the mask can be rubbed off with your finger or a rubber cement pickup. You may want to buy an inexpensive brush that will be used only for applying masking solution. Rub the brush on a damp piece of soap before you use it, and be sure to wash it out as soon as you're finished.

Papers for Special Effects

Five-ply rag bristol board has a very smooth surface. The paint remains on the surface; it doesn't penetrate the paper. This can result in some unique and appealing effects, such as a glass container filled with water or iridescent, transparent flowers. Another advantage of bristol board is that, after the paint has dried, you can lift out specific areas with a damp brush to lighten it almost back to white. This technique was used for the corn kernels in the painting to the right.

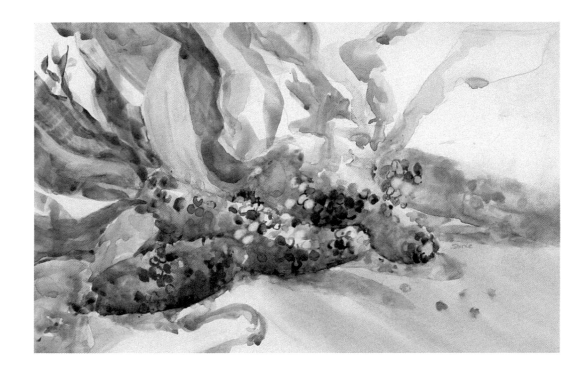

Circular Formats

A square or rectangular mat with a circular or oval opening provides an interesting alternative to regular matting.

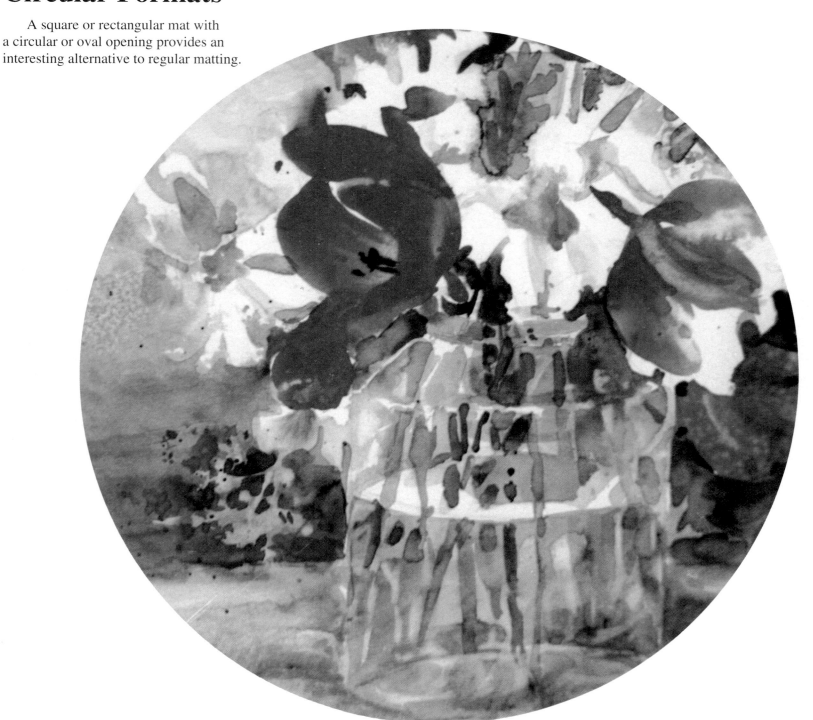

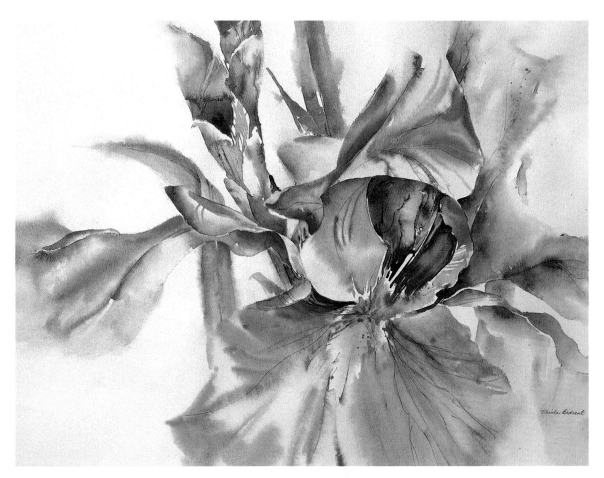

The Exaggerated Close Up View

Create drama in your paintings through the use of a "larger-than-life" blossom with just a few leaves.

Do the Unexpected!

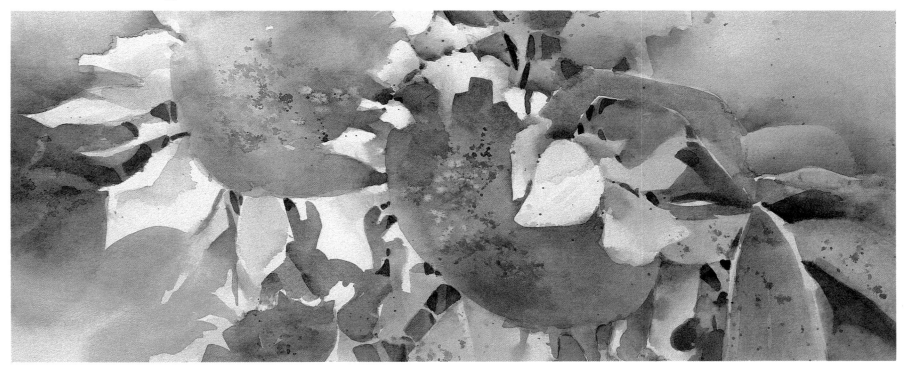

The elongated rectangle, used either horizontally or vertically, is an interesting and dramatic format. The long, narrow shape will fill unique spaces that traditional rectangular paintings cannot. A subject you would ordinarily think of as only vertical or horizontal can be a dramatic surprise when portrayed in the opposite format.

Geraniums

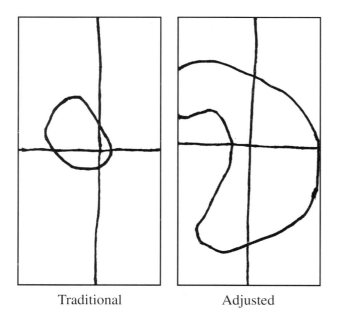

Traditional Adjusted

The composition of this painting has two classic design shapes because of its long, narrow shape. The underlying foundation is an "S," and the focal point is a backwards "C." Traditionally, the focal point of a painting falls into one of four imaginary quadrants and is off-center and away from the edges. This type of focal point would have to be too small to fit in a long, narrow format. For this type of format you must curve and lengthen the focal point, and let it touch the edges to prevent a stripe-like appearance.

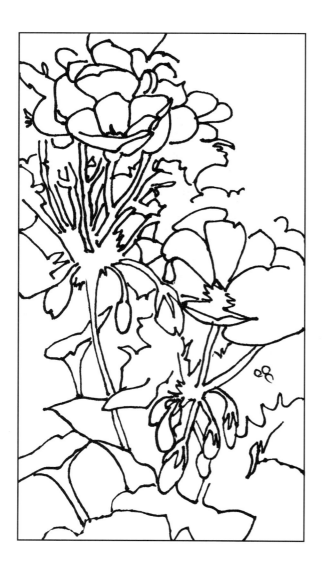

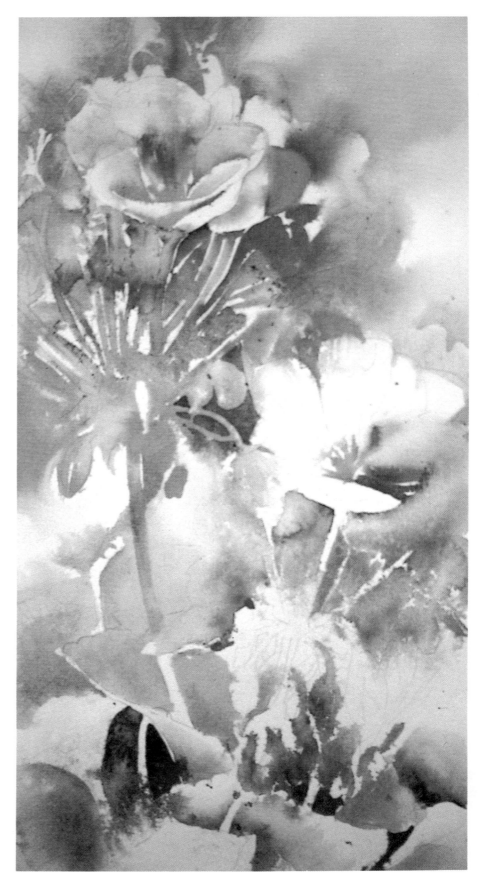

Block in the washes with indian yellow, rose madder genuine, cadmium scarlet, and antwerp blue. Save white areas and soften some edges with a clean, wet brush.

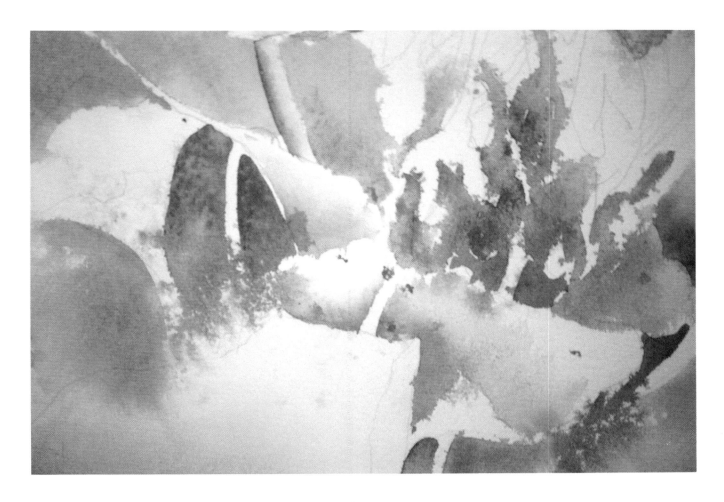

CREATING TEXTURE, PAINTING DETAIL, AND DIVIDING SPACE

Use your pump bottle to spray a light pattern of water on the area of the lower leaves. As you apply the paint, the color will "spider out" into the dots of water, forming a lacy effect to break up the straight, hard edges (above). Add dark background shapes (below) to create depth and detail and to divide the spaces. Use darker mixtures of the same four colors you began with, and add alizarin crimson to make the deepest reds and and to mix darker colors.

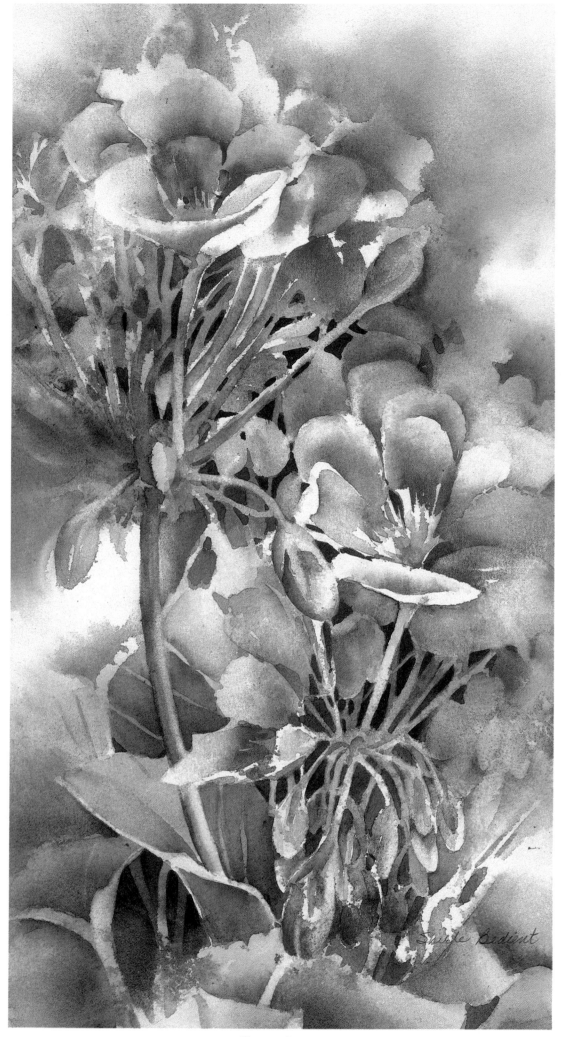

Geraniums

Iris

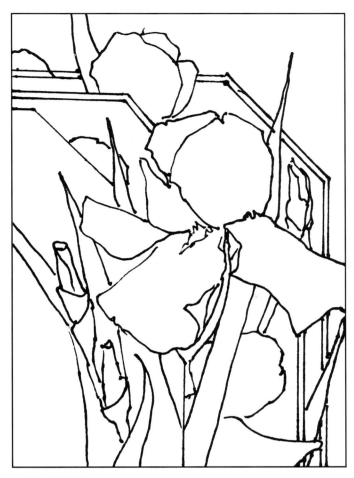

SKETCH

Lightly draw the geometric rectangles, then draw the flowers overlapping and emerging between the layers of rectangles.

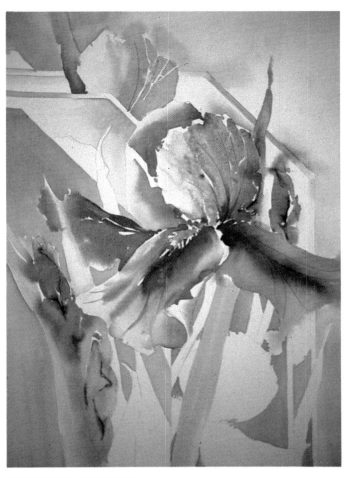

UNDERPAINTING

Block in the washes with your 1" wash brush and rose madder genuine, pthalo. violet, antwerp blue, and raw sienna. Use indian yellow and cadmium scarlet for the beards on the main blossom. Soften some edges with your mist sprayer.

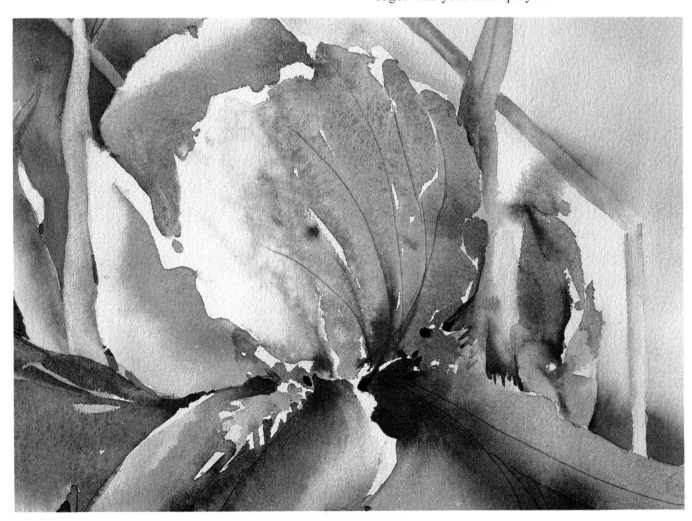

USING WATERCOLOR MARKERS

The deep rose color at the base of the largest upper petal and the rose and blue-gray linework on the buds are applied into the wet washes with flexi-ble-tip markers.

ADDING DARKS AND CREATING DEPTH

The space around or behind the subject of your painting is called "negative space." Adding secondary dark shapes in this negative space helps to define the edges of the blossom and adds depth to the painting. Some areas of the geometric shapes are glazed with deeper blue tones to push them behind the main blossom. Use a little raw sienna and pthalocyanine violet to darken the antwerp blue.

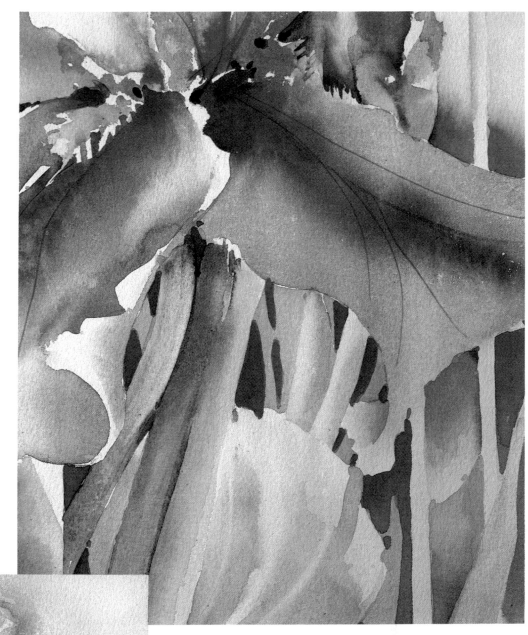

MAKING CHANGES

If necessary, it is possible to wash out a shape even if the painting is near completion. Make sure the painting is completely dry, and then draw the desired shape very lightly. A 1/2" flat brush and clean water are used to gently scrub out the color. Blot frequently and lift out the pigment in one small area at a time. (This technique works best with nonstaining colors.) In this painting, the light leaf was lifted to create a passageway for the eye to travel from the main flower to the upper area of the painting.

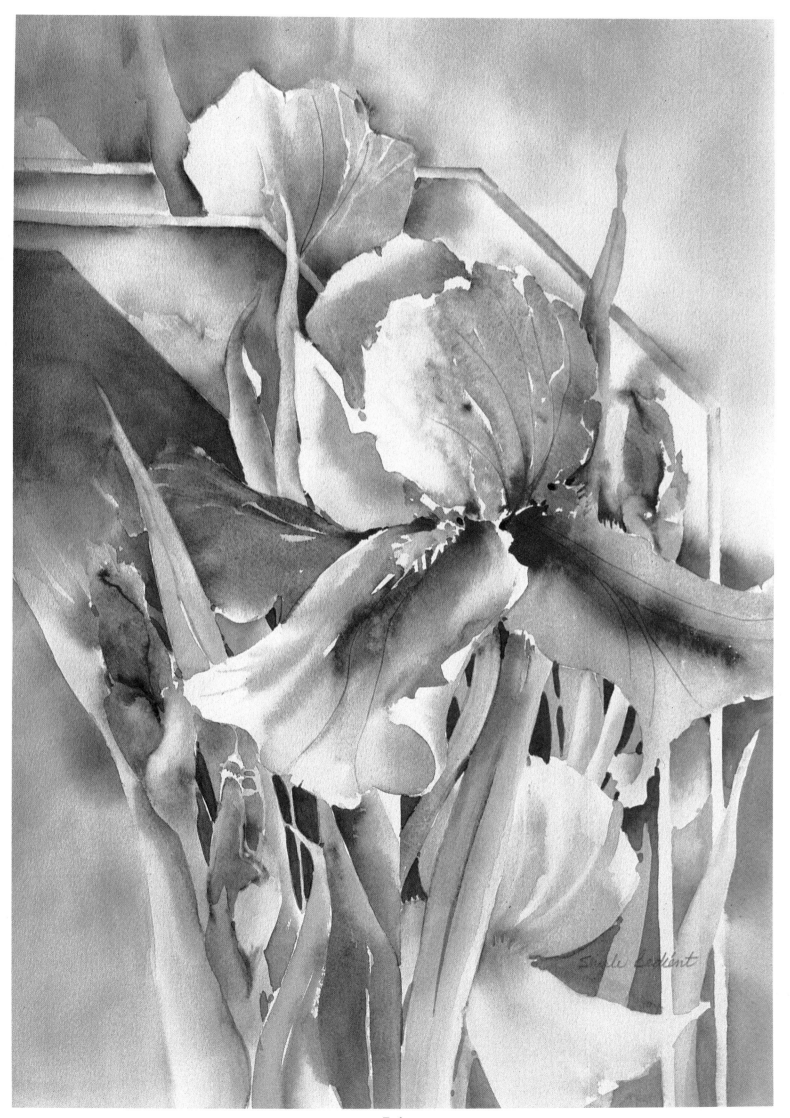

Iris

Using Geometric Shapes for Design

BACKGROUNDS

Introducing geometric shapes with line to create a background "window" creates an updated, contemporary painting.

First draw the subject, keeping it off-center both horizontally and vertically. Refer to the white space around the drawing to determine the placement of the linework "window."

Place the window so that each side is a different distance from the edge of the paper.

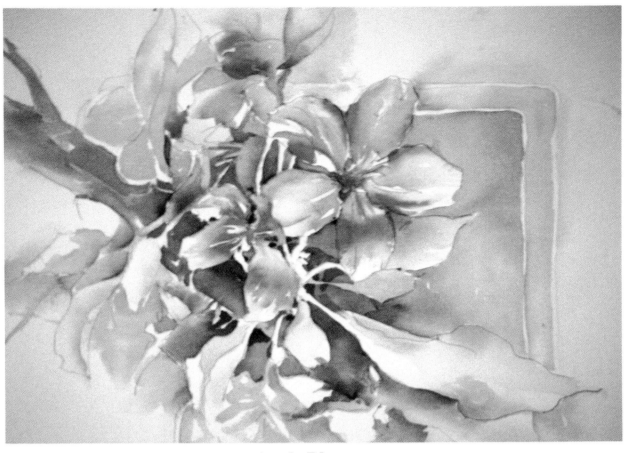

Apple Blossom

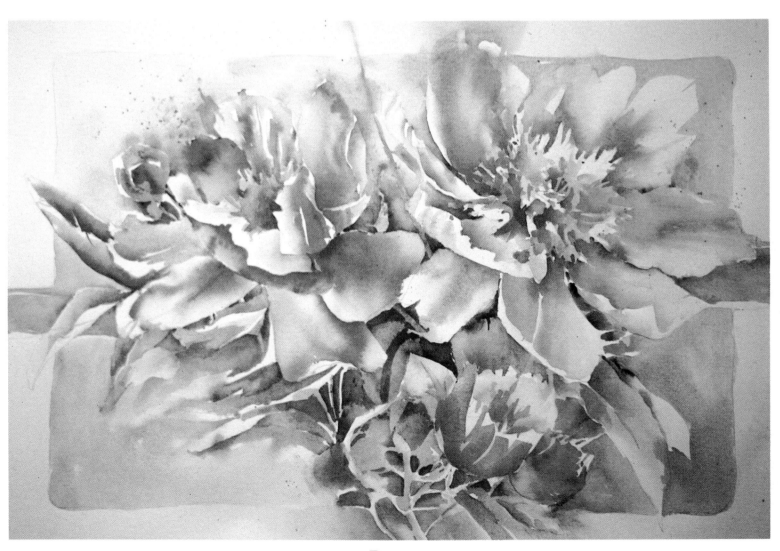

Peony

Your subject can disappear behind or overlap the geometric "window." Not every part of this geometric window needs to be defined. A variation of putting soft color within the rectangle as in the picture above would be leaving the white around your painted image and adding the color outside it.

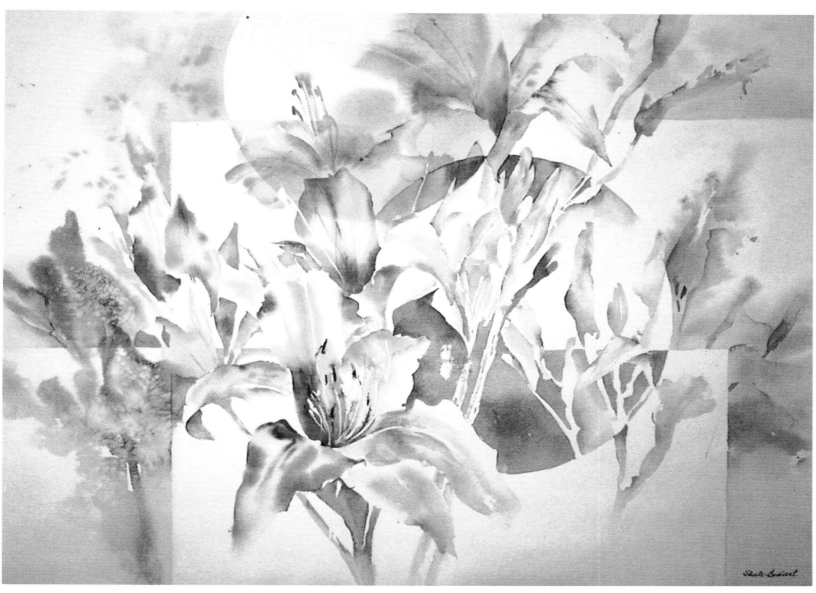

Daylily

VARYING PLANES

Geometric forms can be laid over a drawing after the drawing is completed, as with the paintings on these two pages, or it can be designed into the drawing in layers as with the iris on page 25. These forms allow the artist to create a visual change of planes within the painting. These geometric shapes are emphasized by a combination of painting inside and outside the form and sometimes losing part of an edge of the form. All shapes in any type of painting are formed by the contrast of light against dark—with direct brush strokes or by painting around objects.

Using a Floral Background for Wildlife

This is a very simple sketch. A painting does not have to be completely filled with objects, nor does every square inch of the white paper have to be painted.

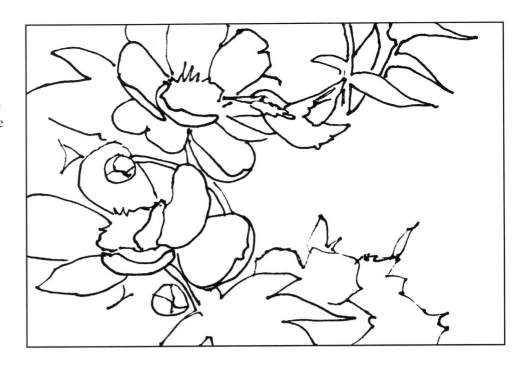

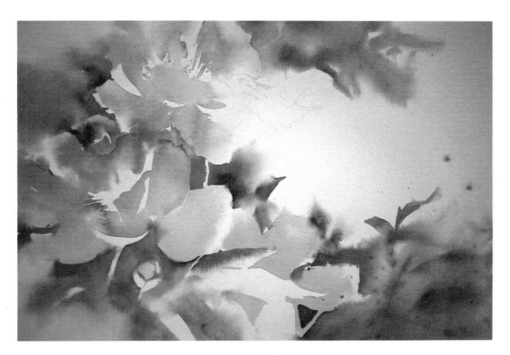

Block in the blossoms and the foliage for this painting in two steps. First apply the rose madder genuine for the blossoms and the raw sienna for the flower centers with your 1" wash brush. Soften some edges with your mist spray bottle, and keep some edges hard. Then, after the pink washes have dried, use antwerp blue and raw sienna for the foliage areas, following the same method of application.

After the foliage washes have dried, paint the hummingbird in full detail, using a dark gray mixture of antwerp blue, alizarin crimson, and pthalocyanine green. Add cadmium scarlet to the mixture for the grayed tan tones. Use pthalo. green and permanent rose for the bright color on the body. When adding the remaining darks to the painting, try not to overshadow the bird.

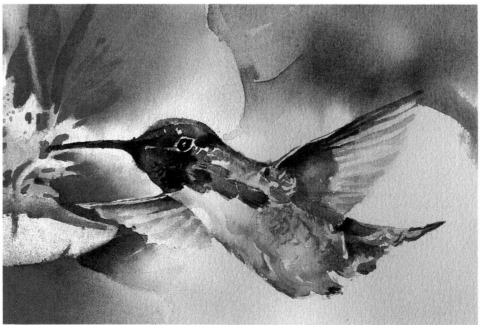

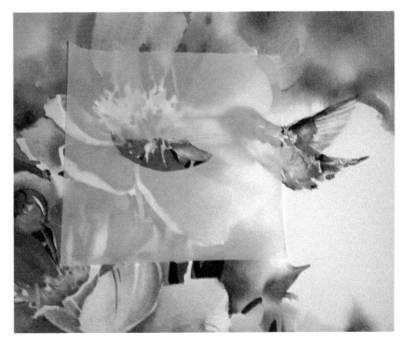

When the painting was almost finished, I realized that I needed to add a petal coming forward to make the hummingbird appear as if it was hovering over the blossom. First, I laid a piece of tracing vellum over the area where I wanted to add the petal, and then drew the petal shape on the vellum in perspective. I then removed the vellum and cut out the petal shape. Next, I positioned the petal stencil on the painting and, while holding it in place with my free hand, used a small elephant ear sponge to wipe away the paint underneath. Once the area dried completely, I was free to paint the new petal.

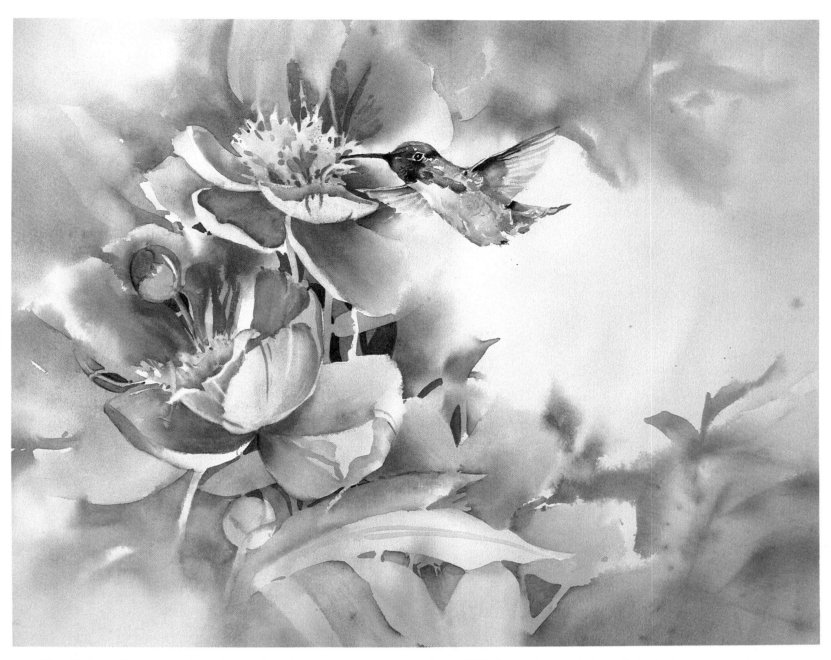

The C-shape formed by the paint on the white paper is a classic design shape for a painting. Some other common designs are the "U" and the "S." You can turn them on their side or upside down. This is another variation of the dark pattern design. As you do your sketch, think about these design shapes as a pattern for the application of your initial washes.

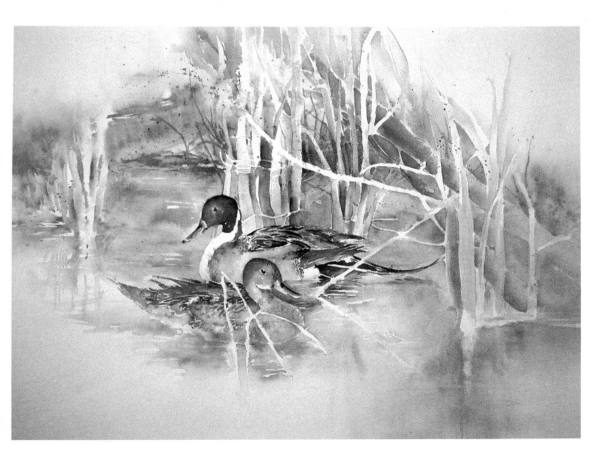

Foliage is a good subject for the floral painter who would like some variety. There were no ducks in the reference photo of these reeds. I placed the ducks where I wanted them. The library is a good resource for pictures of wildlife to use as models.

A Final Touch of Light

No matter how hard you try to save the whites, you may still wish you had left more highlights. The wash-out methods demonstrated on pages 24 and 29 are two ways to recapture them. Following are three more methods. Note: All of these techniques affect the surface of the paper and how it will accept future applications of paint. Practice them on a scrap of paper before you do them on a painting.

FIFTEEN SECONDS AND ERASE

This technique works best for small shapes and lines. Use a small brush to paint water over the areas you want to wipe out, then count to fifteen, blot well with a clean tissue, and erase immediately. (This technique does not work on soft papers.)

SANDPAPER

You can lighten an area by rubbing it very gently with fine sandpaper.

RAZOR SCRAPING

Use the pointed corner of a safety-edge razor blade to scratch in fine-line highlights after the painting is completely dry. Also, you can use the flat edge of the razor to lightly scrape the paper, lifting the high spots to subtly lighten the area.

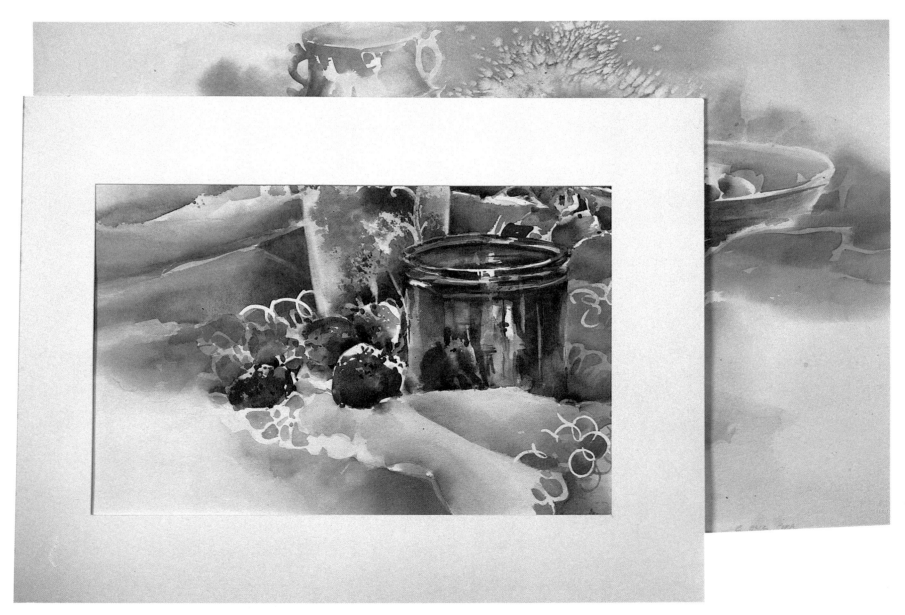

FINDING A SMALL PAINTING TO SAVE

Take two L-shaped pieces of mat board and overlap them to make a small rectangle you can move around over the failed painting to find a section worth saving. Smaller sections make charming greeting cards or gift enclosures in a greeting card.

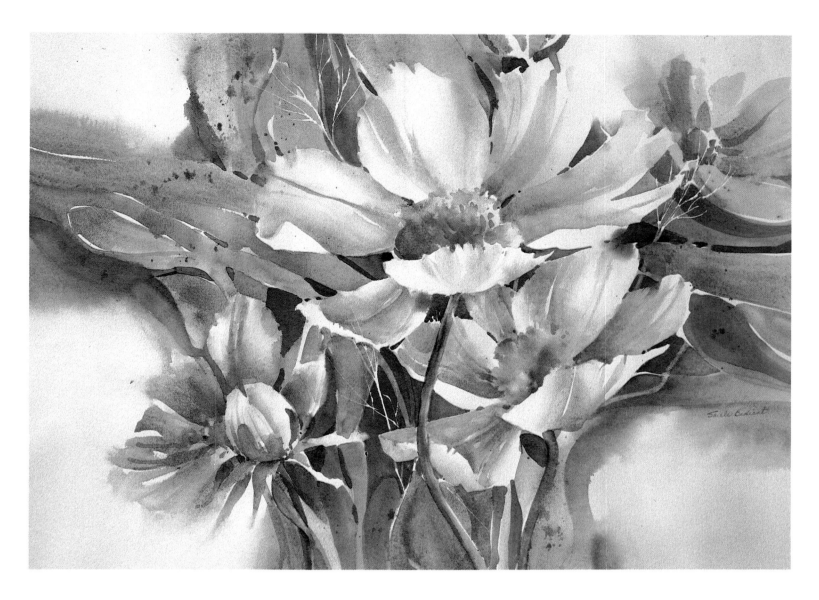

Many people feel that the background is the most diffi-cult part of a floral painting. The background for *White Cosmos* (above) is simply wavy ribbons of color that sweep out to the edges of the paper forming a dark pattern design of cobalt blue, cobalt violet, raw sienna, and antwerp blue. Let the wet colors touch in some places, and leave a fine line of white along other edges. *Company's Coming* (below) is a unique overhead view of a bouquet. Sketch the bouquet first, and then use a ruler when drawing the checks.

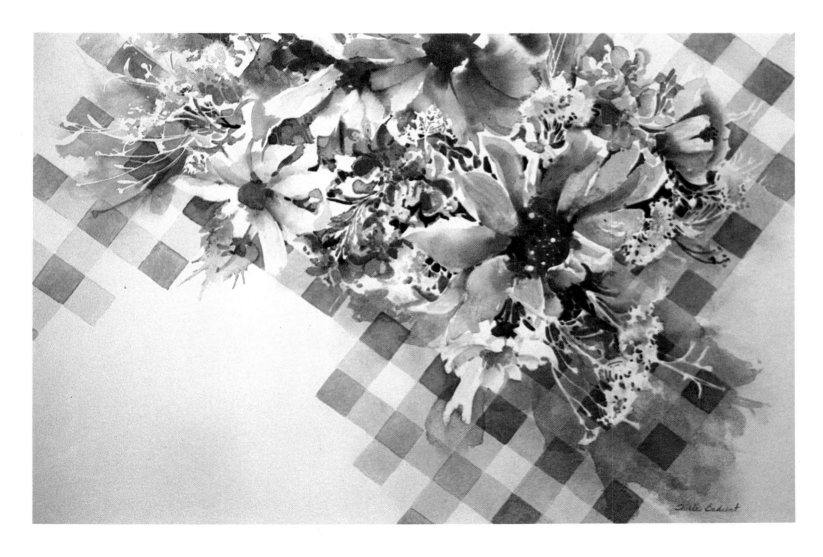

More Ways to Learn!

The **Artist's Library** series offers both beginning and advanced artists many opportunities to expand their creativity, conquer technical obstacles, and explore new media. You'll find in-depth, thorough information on each subject or art technique featured in the book. Each book is written and illustrated by a well-known artist who is qualified to help take eager learners to a new level of expertise.
Paperback, 64 pages, 6-1/2" x 9-1/2"

Collector's Series books are excellent additions to any library, offering a comprehensive selection of projects drawn from the most popular titles in our How to Draw and Paint series. These books take the fundamentals of a particular medium, then further explore the subjects, styles, and techniques of featured artists.
CS01, CS02: Paperback, 144 pages, 9-1/2" x 12"
CS03: Paperback, 224 pages, 10-1/4" x 9"

The **How to Draw and Paint** series includes books on every subject and medium to meet any artist's needs. These books provide clear step-by-step instruction, beautiful drawings and paintings, and helpful tips to teach aspiring artists the foundations of the art.

This series has seven collections—*Animals, Still Lifes, Portraits & Figures, Seascapes, Landscapes, Cartoons,* and *Special Subjects*. Each title has been authored and illustrated by well-known artists who have volumes of professional expertise to share.
Paperback, 32 pages, 10-1/4" x 13-3/4"

Walter Foster products are available at art and craft stores everywhere. Write or call for a FREE catalog that includes all of Walter Foster's titles.

Walter Foster Publishing, Inc. • 23062 La Cadena Drive • Laguna Hills, CA 92653 • (800) 426-0099

32